Exotic Chickens

Coloring for Everyone

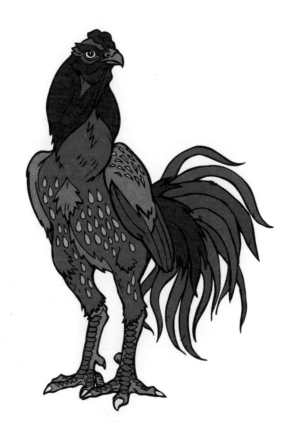

Racehorse Publishing

Copyright © 2016 by Racehorse Publishing, an imprint of Skyhorse Publishing, Inc.

Art credits:
Shutterstock/Anastasia Bobrova (Intro image, wattle)
Shutterstock/Frank Chen Photography (Intro image, eggs)
Shutterstock/Jodie Nash (Intro image, Plymouth rock hen)
Shutterstock/Tanor (Intro image, rooster)
Black-and-white illustrations by Arkady Roytman
Colorization by Timothy Lawrence

Racehorse Publishing books may be purchased in bulk at special discounts for sales promotion, corporate gifts, fund-raising, or educational purposes. Special editions can also be created to specifications. For details, contact the Special Sales Department, Racehorse Publishing, 307 West 36th Street, 11th Floor, New York, NY 10018 or info@skyhorsepublishing.com.

Racehorse Publishing is an imprint of Skyhorse Publishing, Inc.®, a Delaware corporation.

Visit our website at www.skyhorsepublishing.com.

10 9 8 7 6 5 4 3

Library of Congress Cataloging-in-Publication Data is available on file.

Cover design by Jane Sheppard
Cover artwork credit: illustration by Arkady Roytman; colorization by Timothy Lawrence
Text by Chamois S. Holschuh

Print ISBN: 978-1-5107-1225-6

Printed in China

Exotic Chickens:
Coloring for Everyone

Which came first: the chicken or the egg? Ah, the age-old question. Well, this is a coloring book about chickens, so we're going with that! These fine specimens of poultry have pecked their way into the hearts of millions—and not just farmers! As you'll notice in this collection of fabulous feathered designs, chickens are a beautifully varied brood (which, by the way, is the technical term for a group of chickens, along with "clutch" and "peep"). Whether it's the classic Leghorn and Orpington chickens that hold a special place in your heart or the striking Houdans and Dutch Bantams that catch your eye, there's sure to be a chicken breed that tickles your fancy.

Indeed, people have been fascinated by these feathered creatures for quite some time. Descendants of the tropical red junglefowl, chickens were first domesticated as far back as 5400 BCE in China and were eventually transported around the globe. Since then, humans have continued raising chickens for their eggs and meat, and now there are over nineteen billion chickens in the world today. That's more than any other species of bird or domestic animal! Even so, you might be surprised how often chickens are referenced in our everyday lives. You've heard the phrases "she flew the coop" and "don't count your chickens before they hatch." You've probably heard your grandmother refer to herself as "no spring chicken." When you show off, you're said to be "strutting your stuff," and maybe you even like to "shake a tail feather" every once in a while. "Nesting" is the term applied to an expectant mother's preparation of a nursery or even the settling-in period of a couple in their first home.

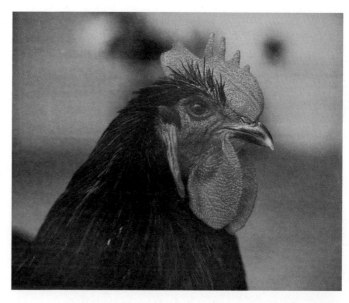

The little bag of skin that hangs beneath a rooster's beak is called a "wattle," while his fancy headdress is called a "comb."

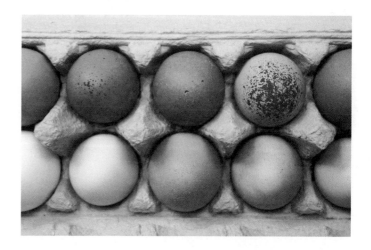

The breed of a hen determines the color of her eggs. For example, the golden-feathered Orpington lays brown eggs while the Ameraucana, which varies in feather color, lays blue eggs.

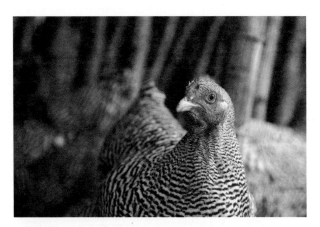

The Plymouth Rock chicken is known for its distinctive black-and-white barred pattern.

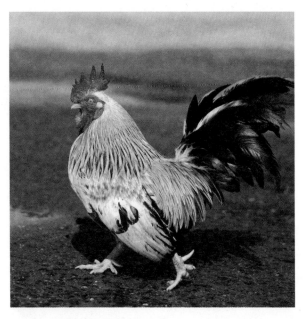

Roosters' tails are multifunctional: they help with balance while the top-heavy birds walk or run; and the showier his tail, the more likely he is to attract mates.

Conversely, parents whose grown children have recently moved out on their own may suffer "empty nest syndrome." And, of course, the most well-known riddle of all: "Why did the chicken cross the road?" All of these sayings, among many others, have their origins in the characteristic and sometimes odd behaviors of chickens and roosters—not many animals can claim such a pervasive presence in the English language. Beyond idioms and jokes, chickens are regarded fondly elsewhere in human cultures. They feature in children's stories and fairy tales like "Chicken Little" and "The Bremen Town Musicians." Audiences clucked their approval of the uproarious antics of poultry in the claymation film *Chicken Run*. And who can forget the obnoxious *hoooonk* of the classic toy, the rubber chicken?

In any case, whether you're a farm fowl fan or you simply love to color, this adult coloring book will keep you entertained for hours. There are pre-colored versions of each design to provide inspiration and guidance, but you can certainly be as innovative as you like with your color choices. Toward the end of the book, you'll also find color bars where you can test your palette. The pages are even perforated, so you can easily remove the black-and-white designs for a more convenient coloring experience. So, gather your coloring utensils of choice, get comfortable, and get creative. When you're finished, place those cluckers on display for all your friends to admire!

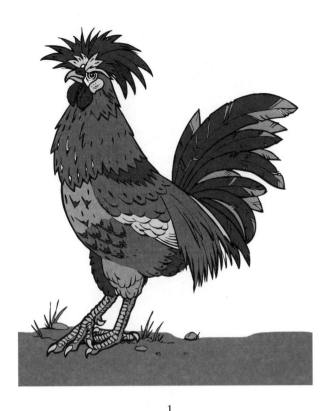

1

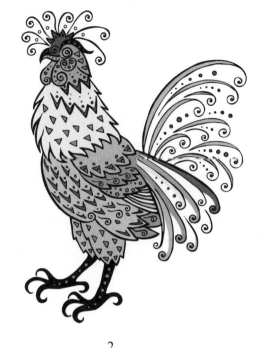

2

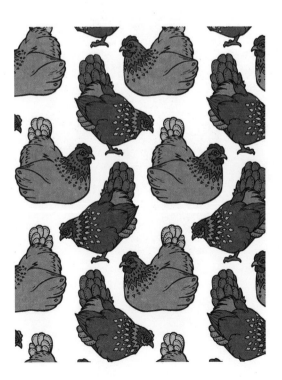

3

4

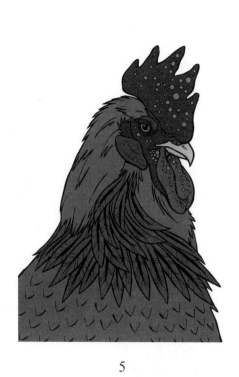

5

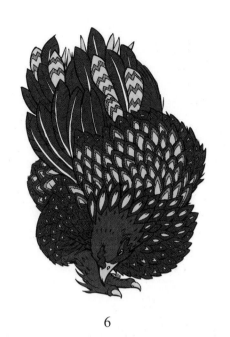

6

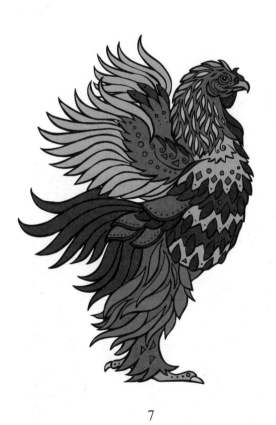

7

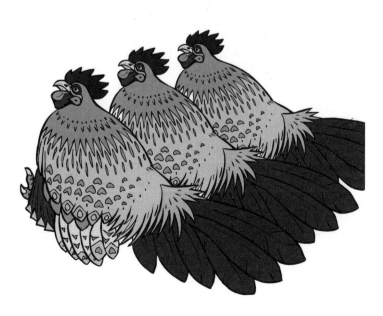

8

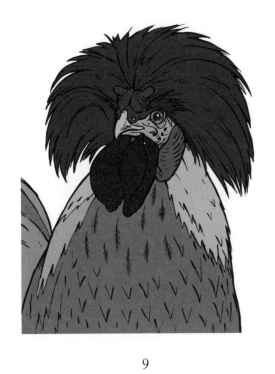

9

10

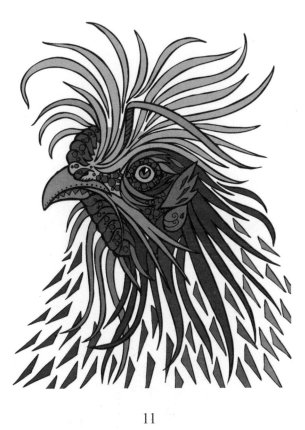

11

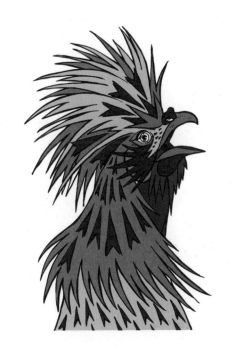

12

13

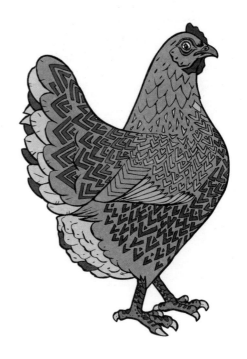

14

15

16

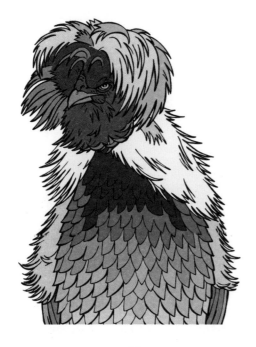

17

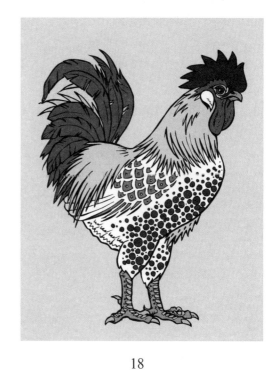

18

19

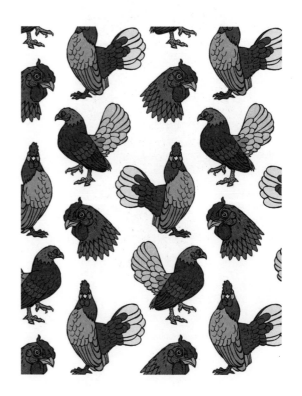

20

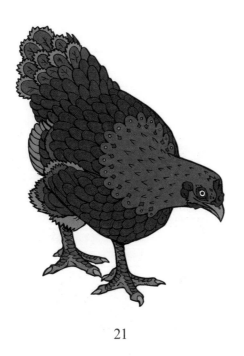

21

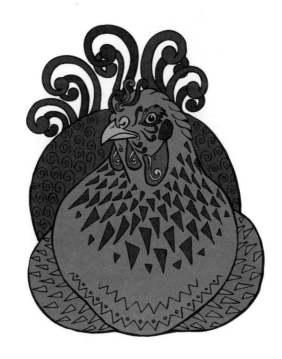

22

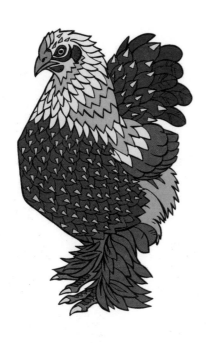

23

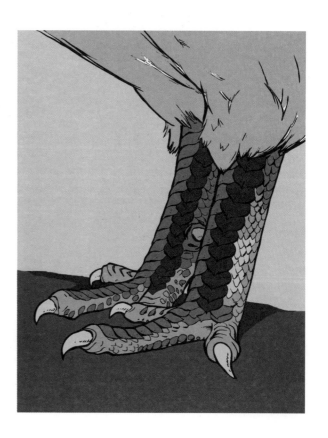

24

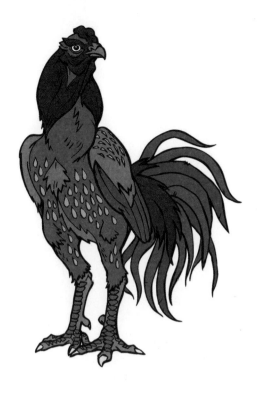

25

26

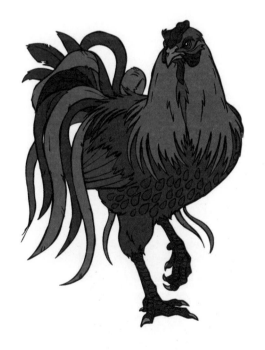

27

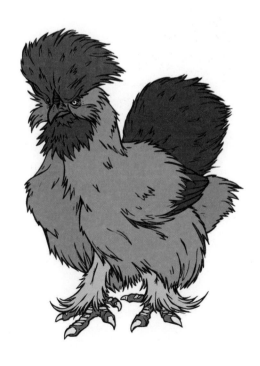

28

29

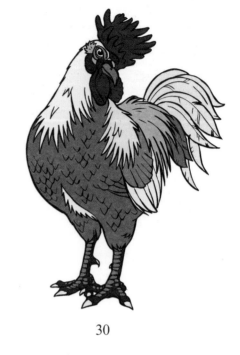

30

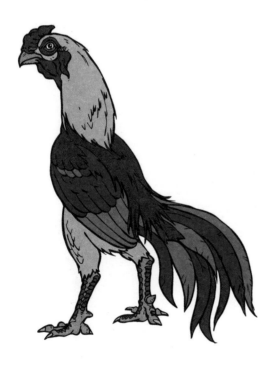

31

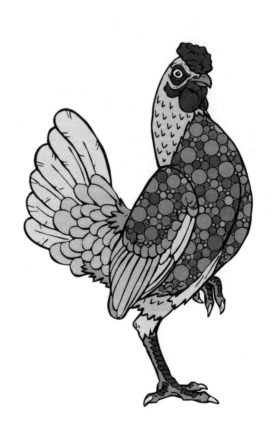

32

33

34

35

36

37

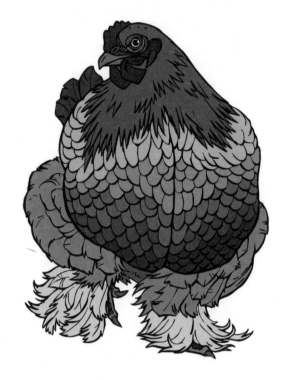

38

39

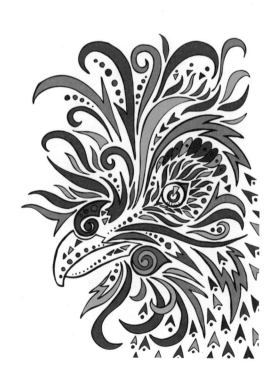

40

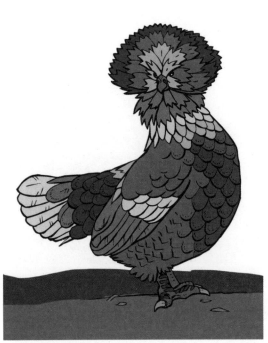

41

42

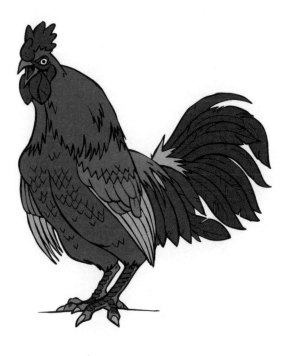

43

44

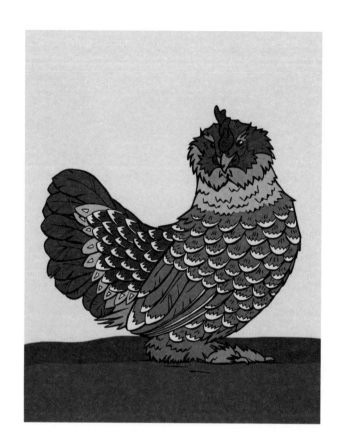

45

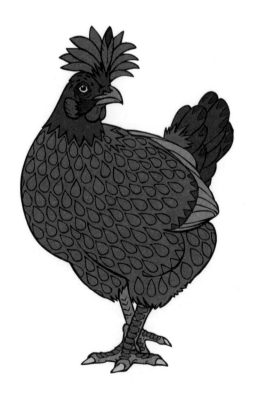

46

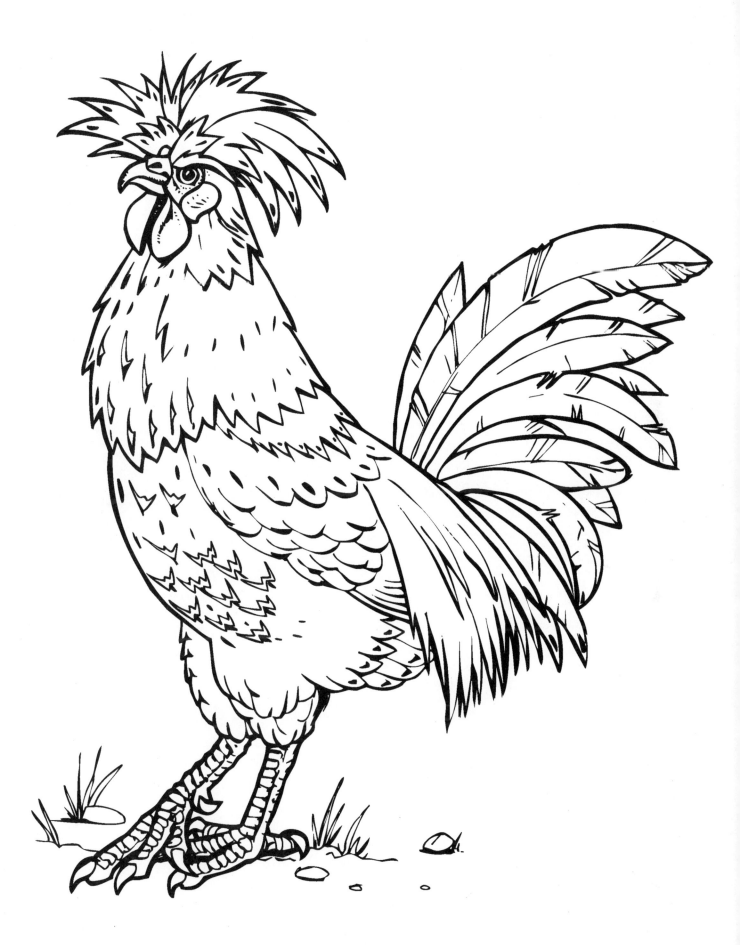

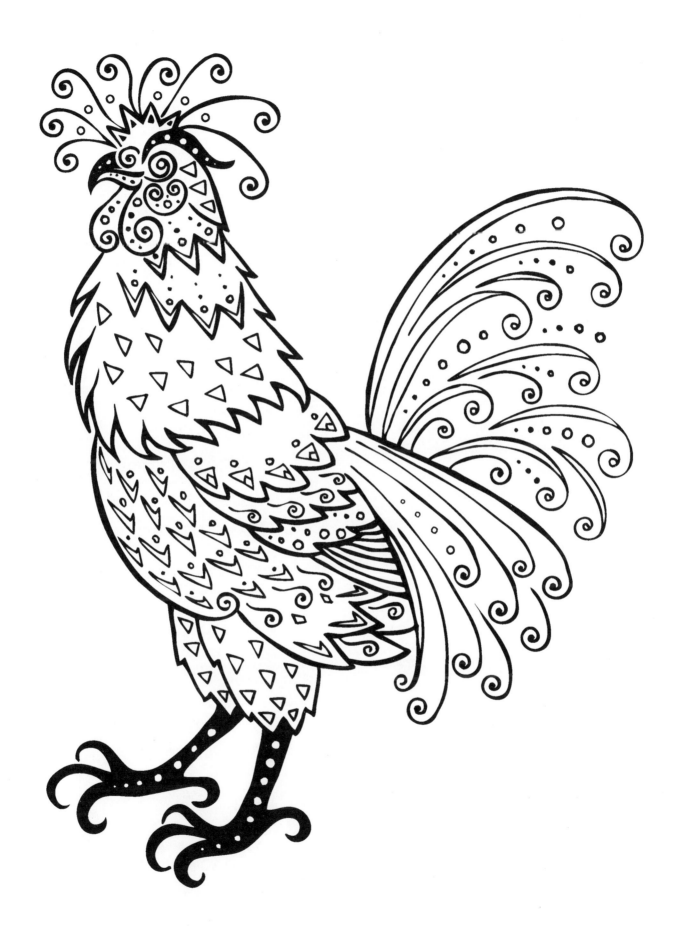

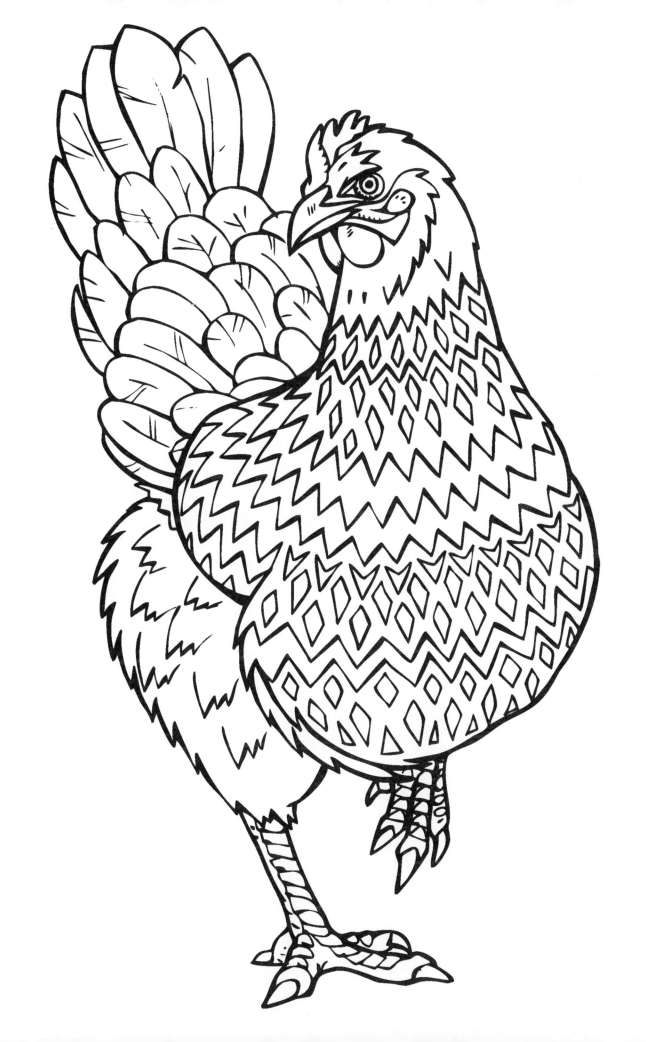

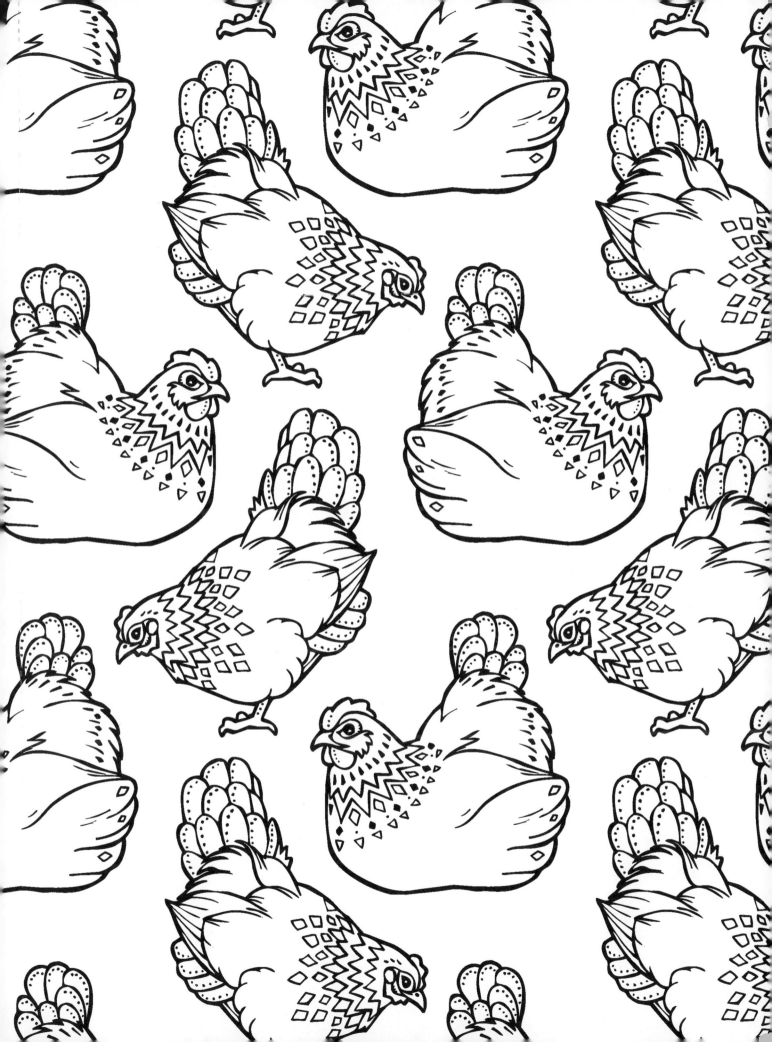

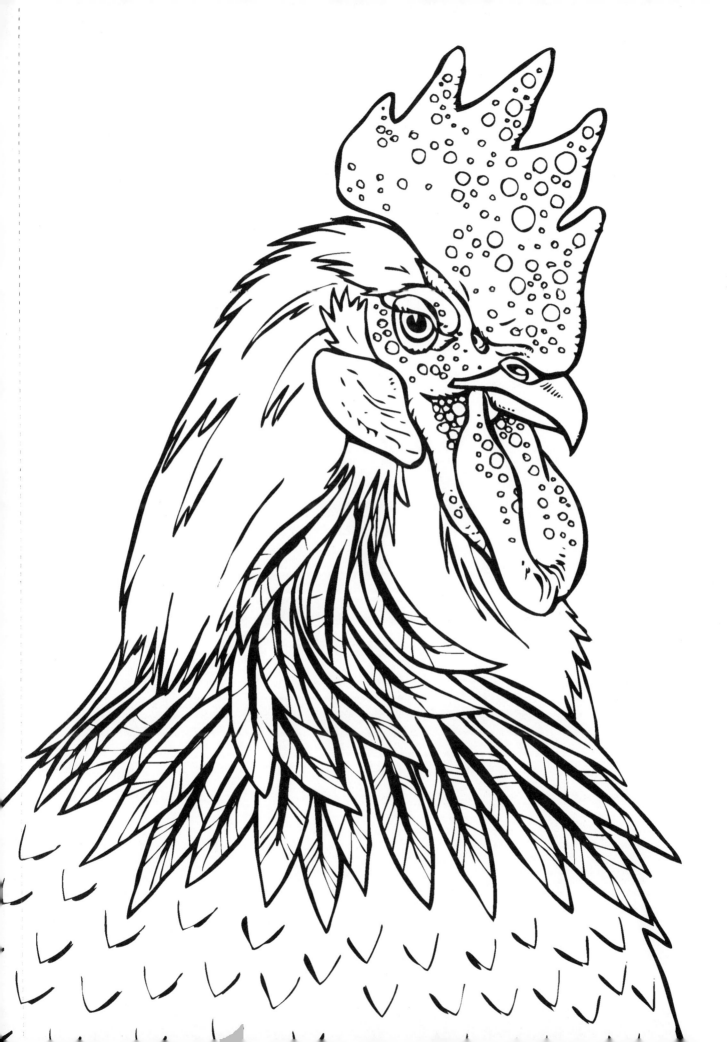

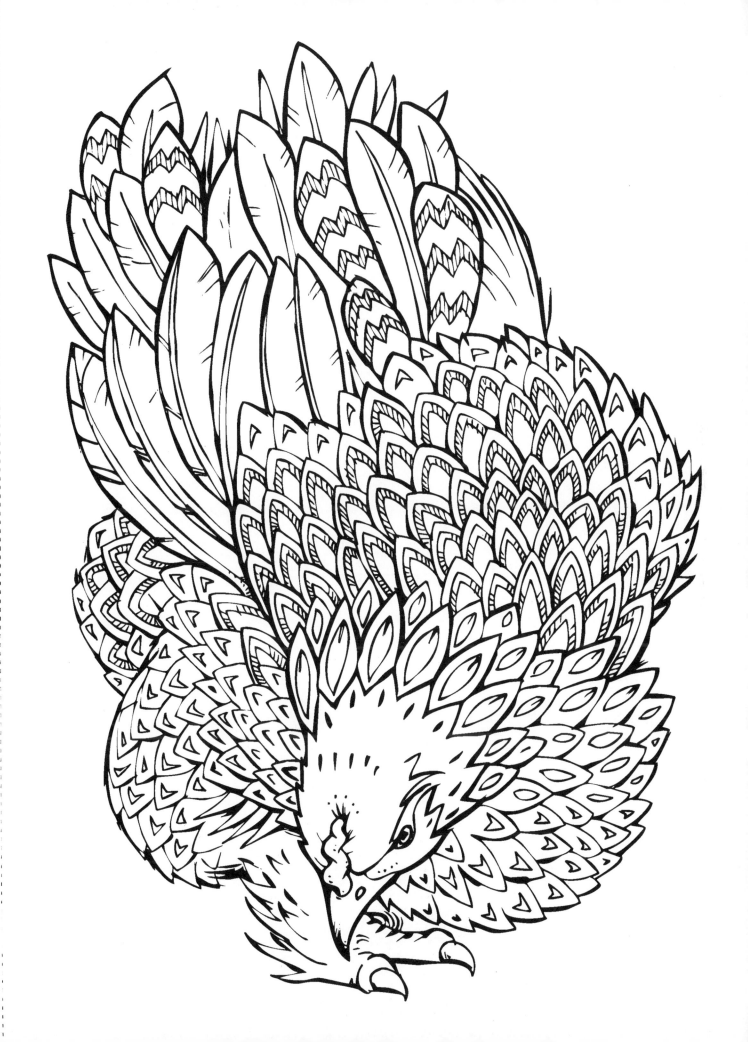

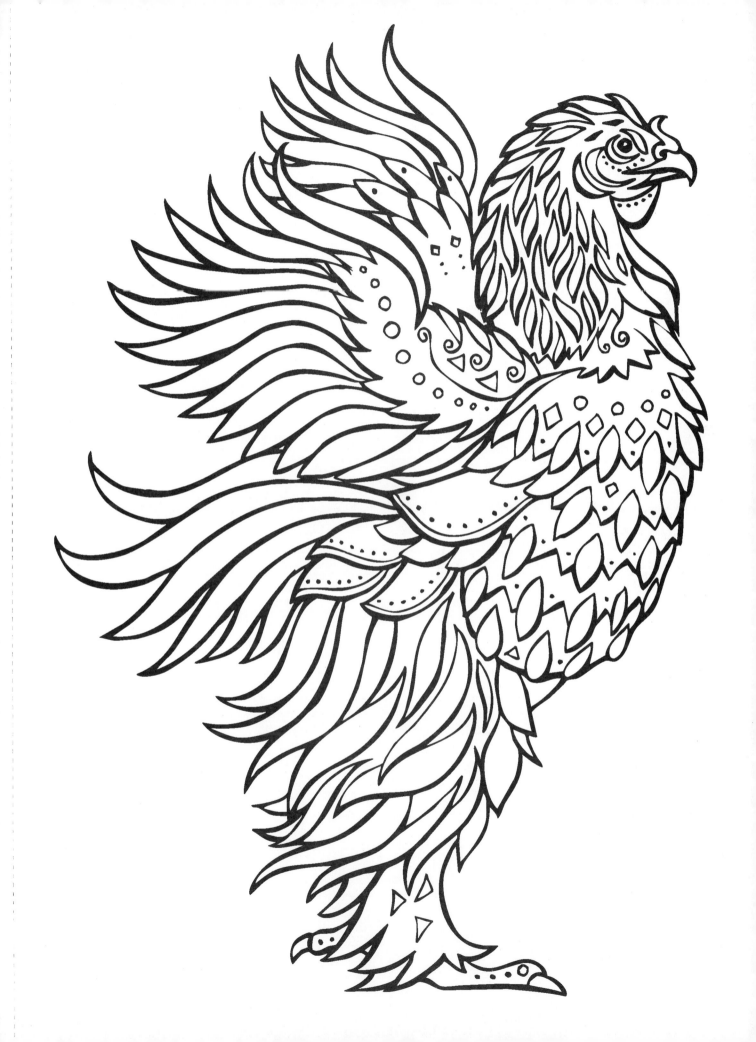

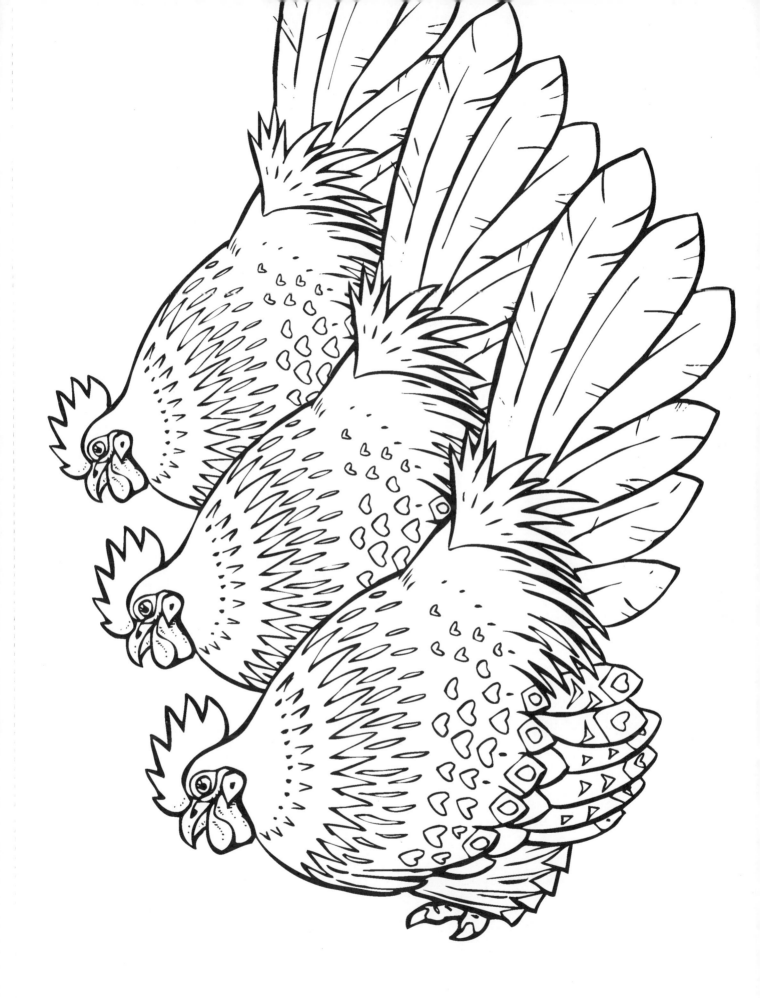

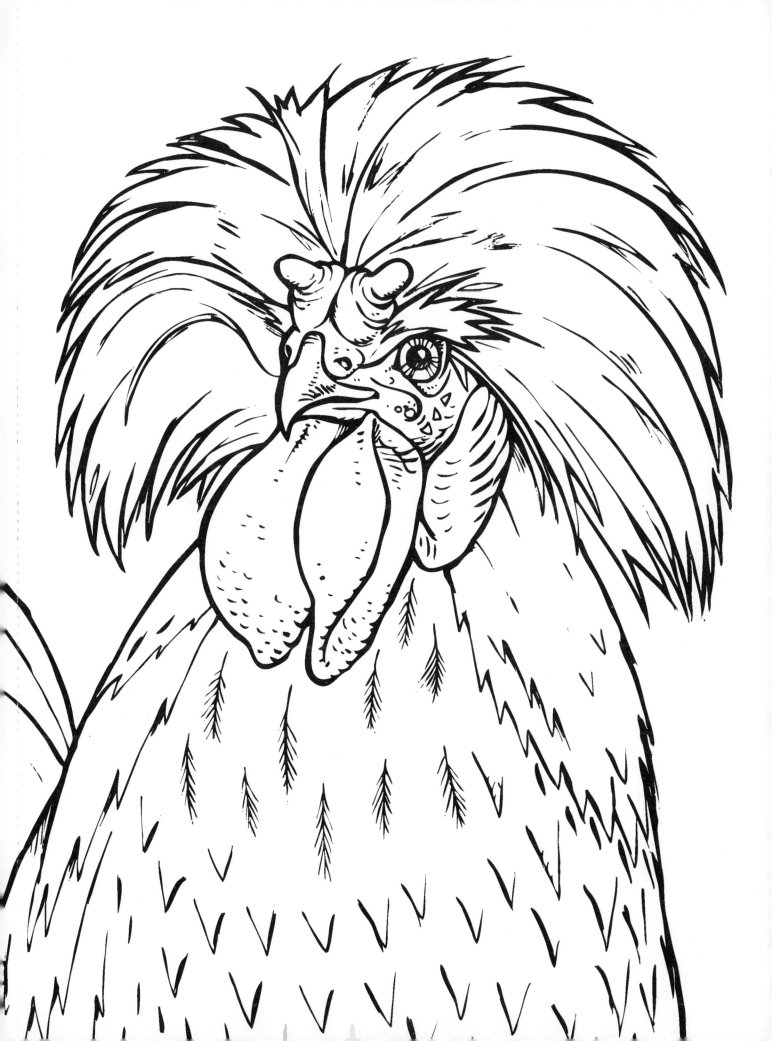

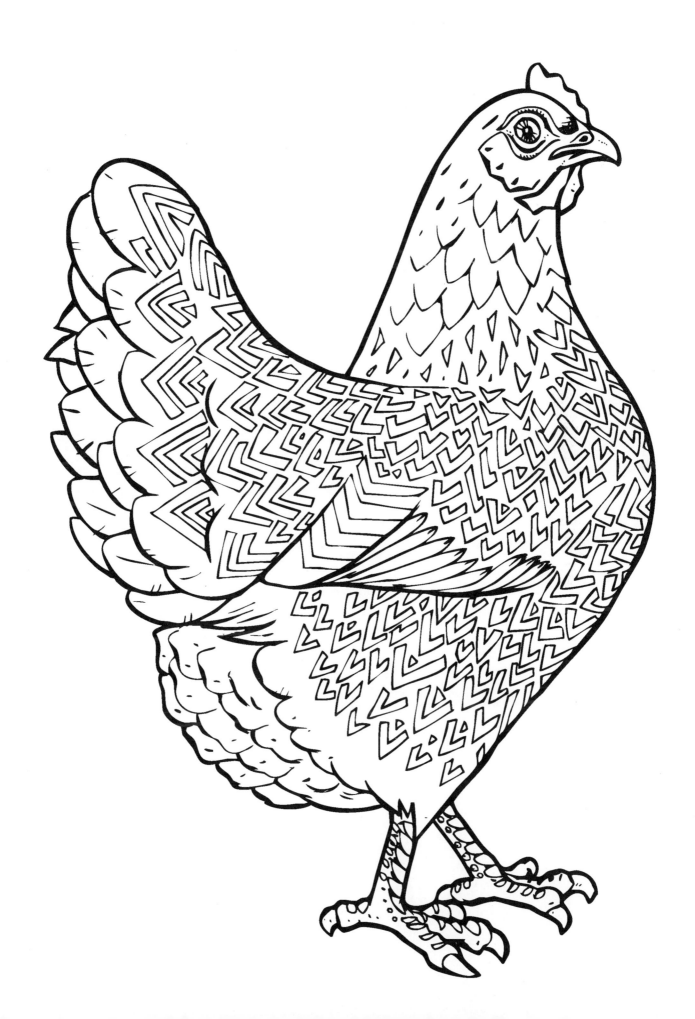

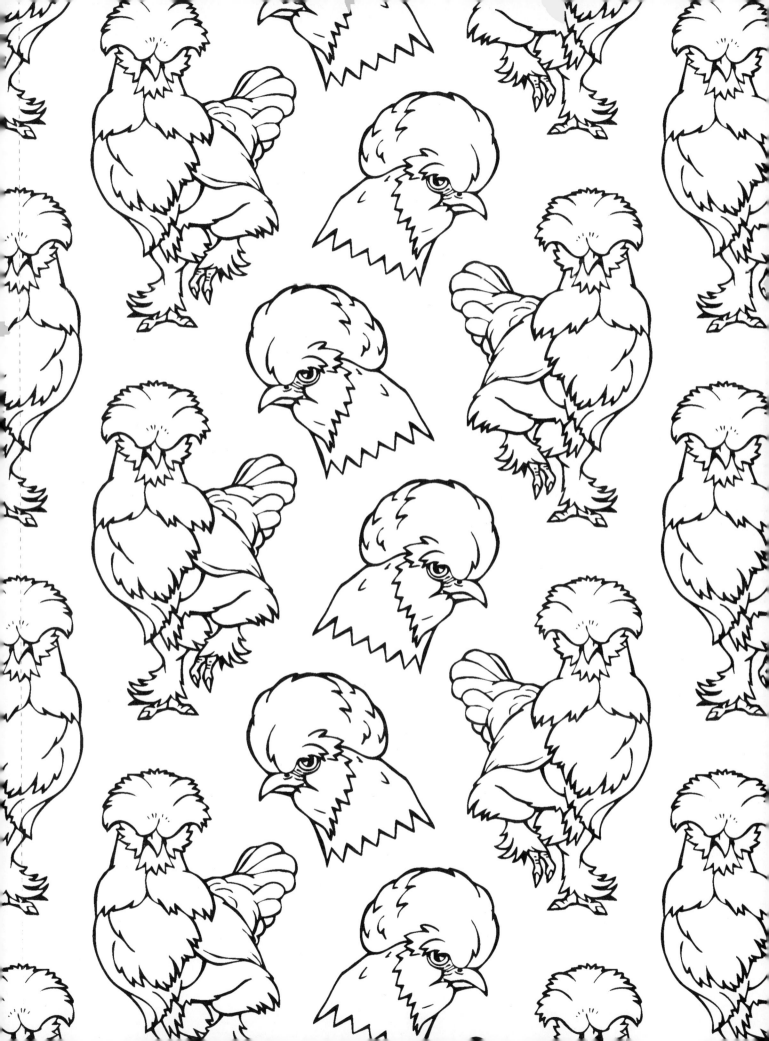

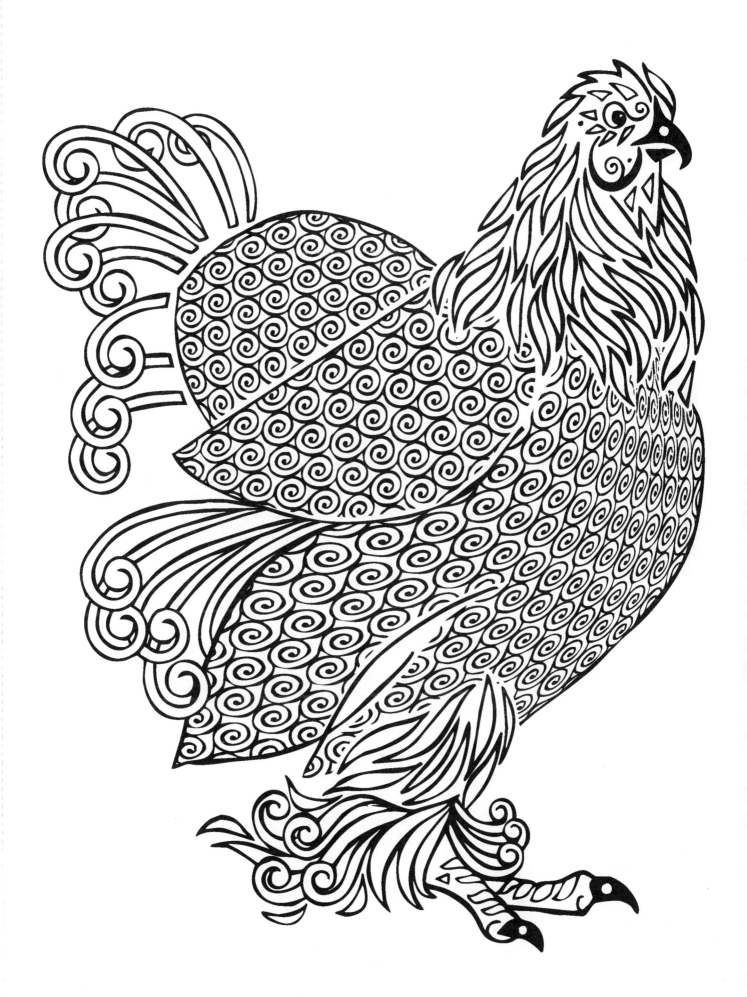

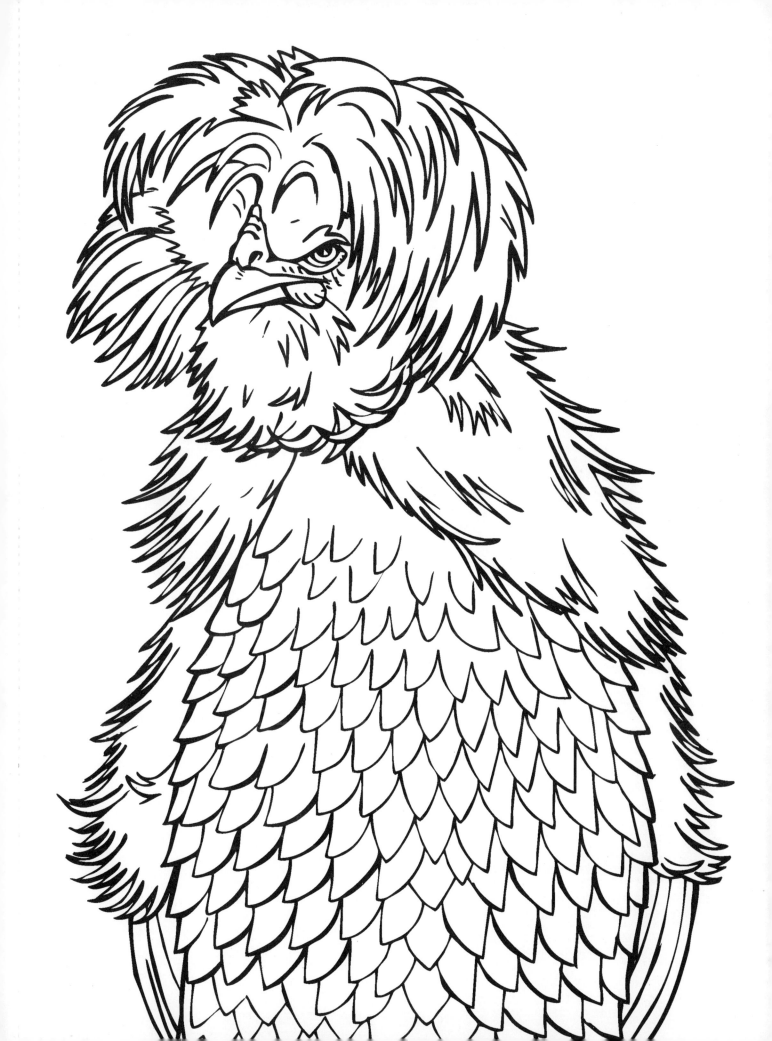

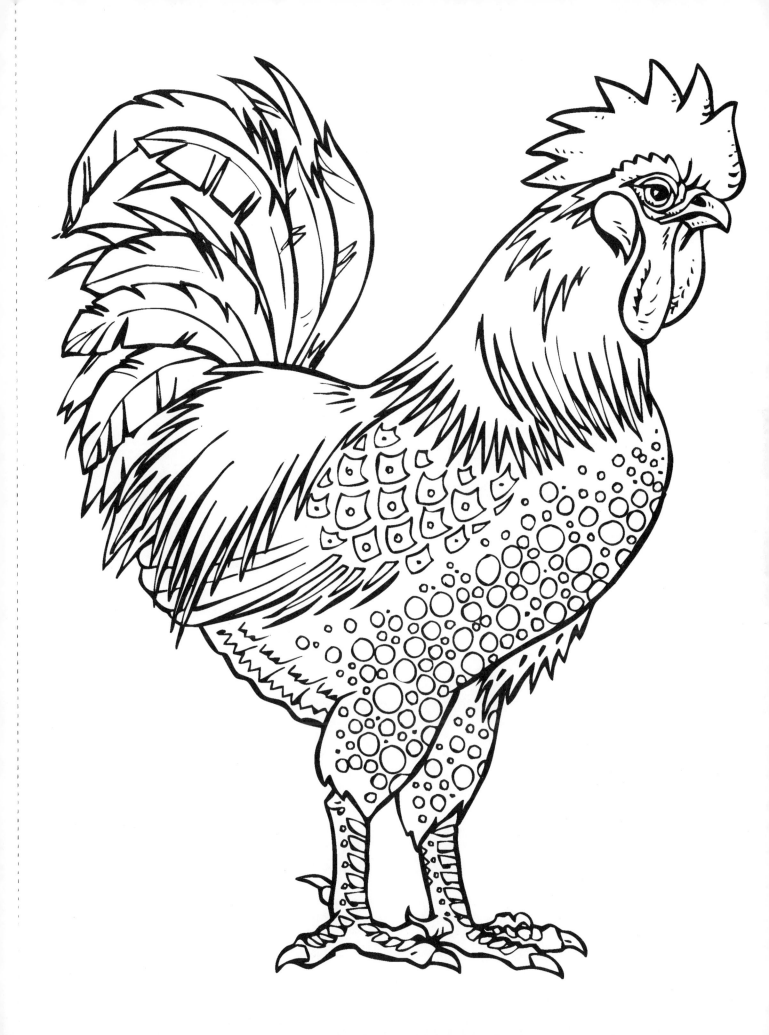

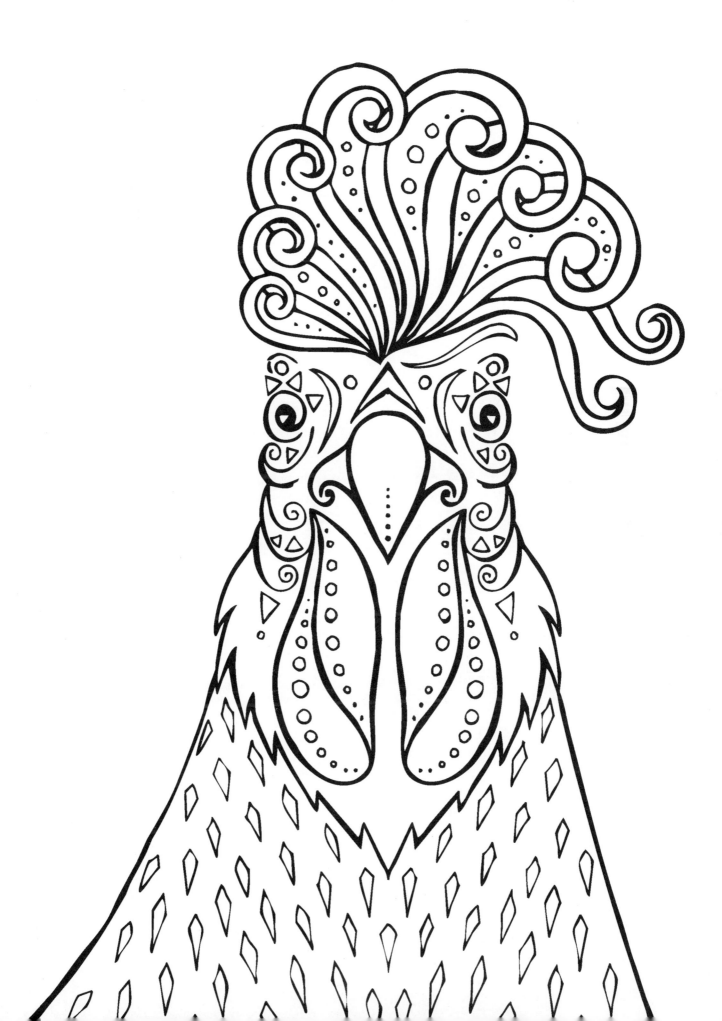

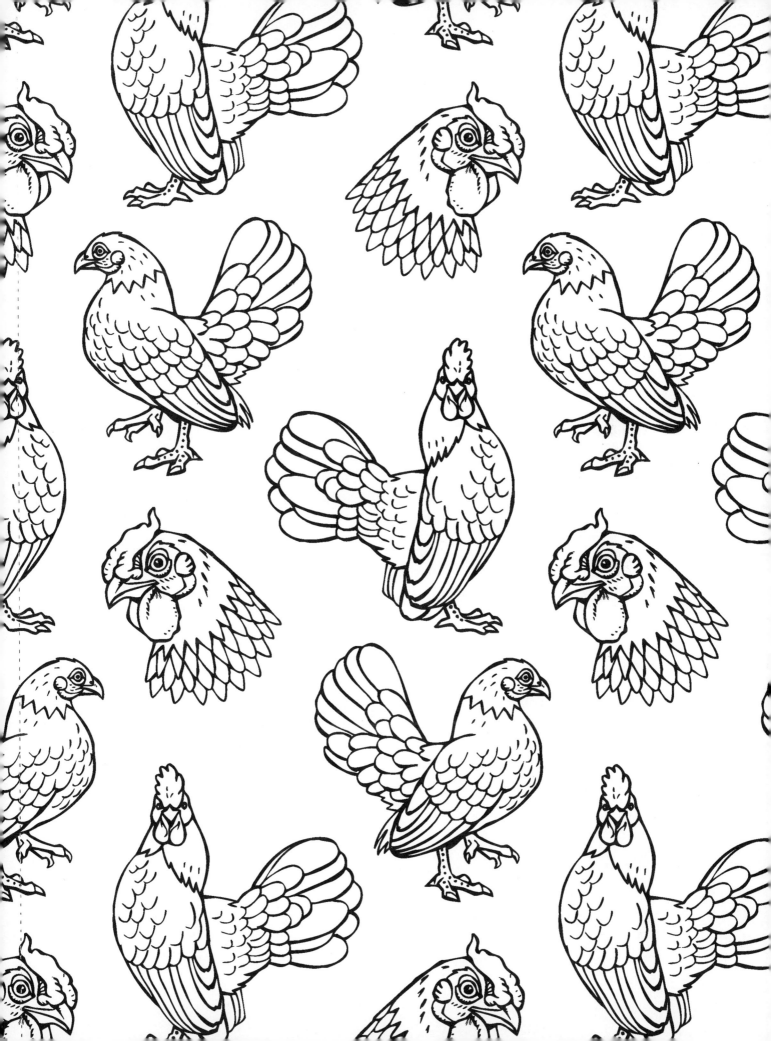

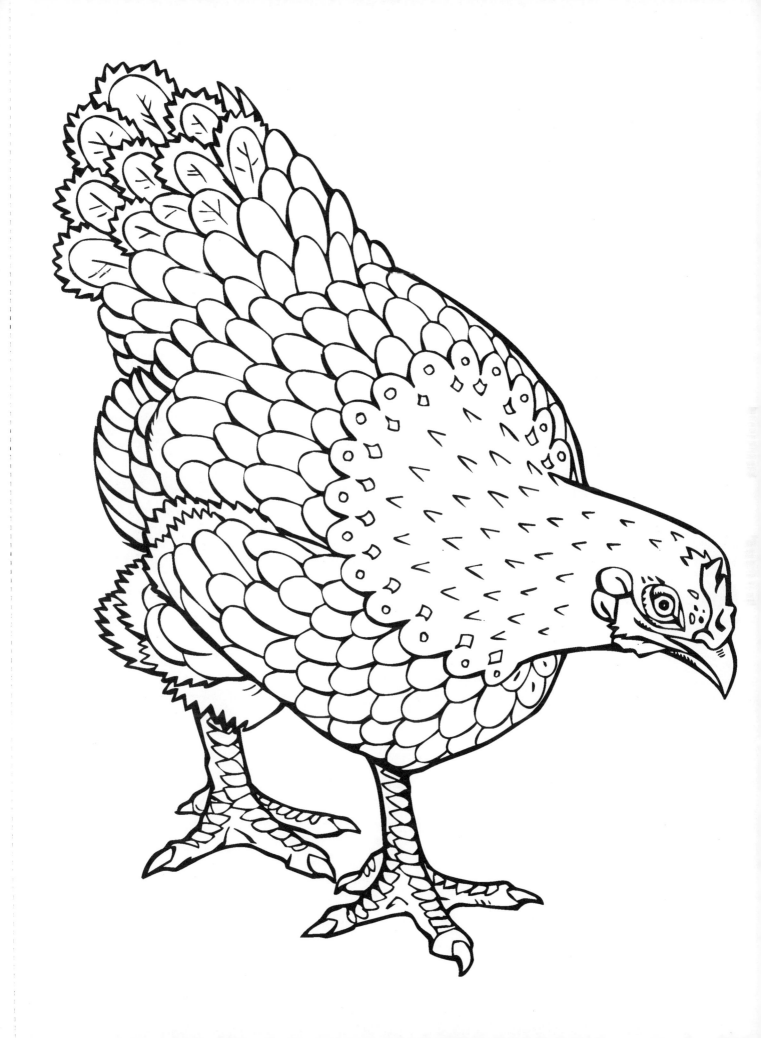

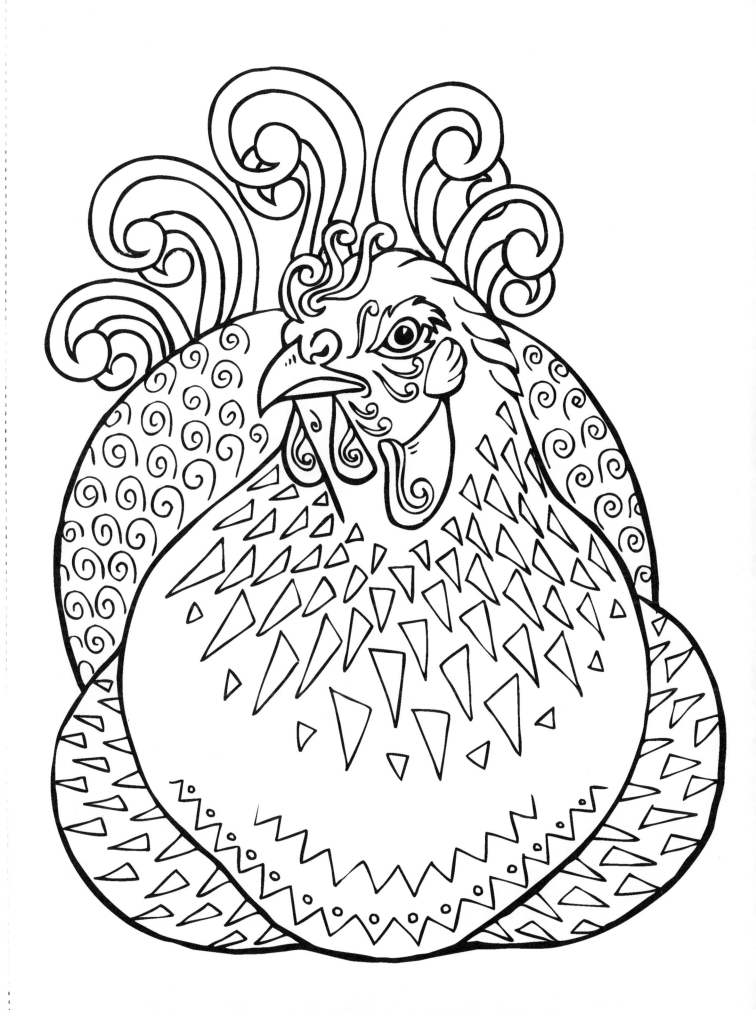

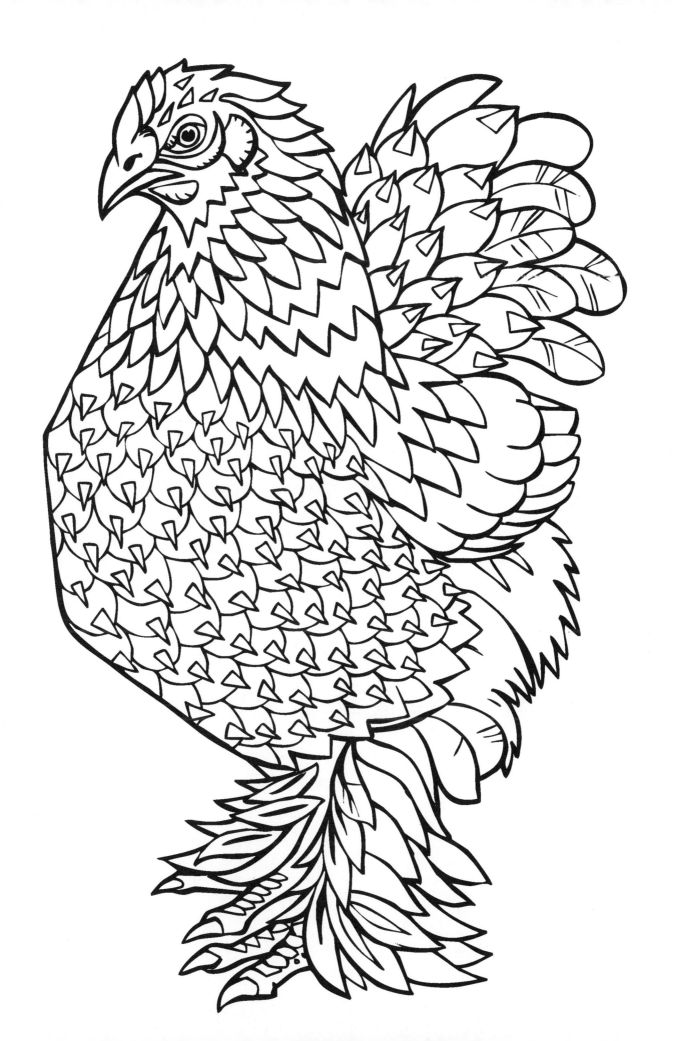

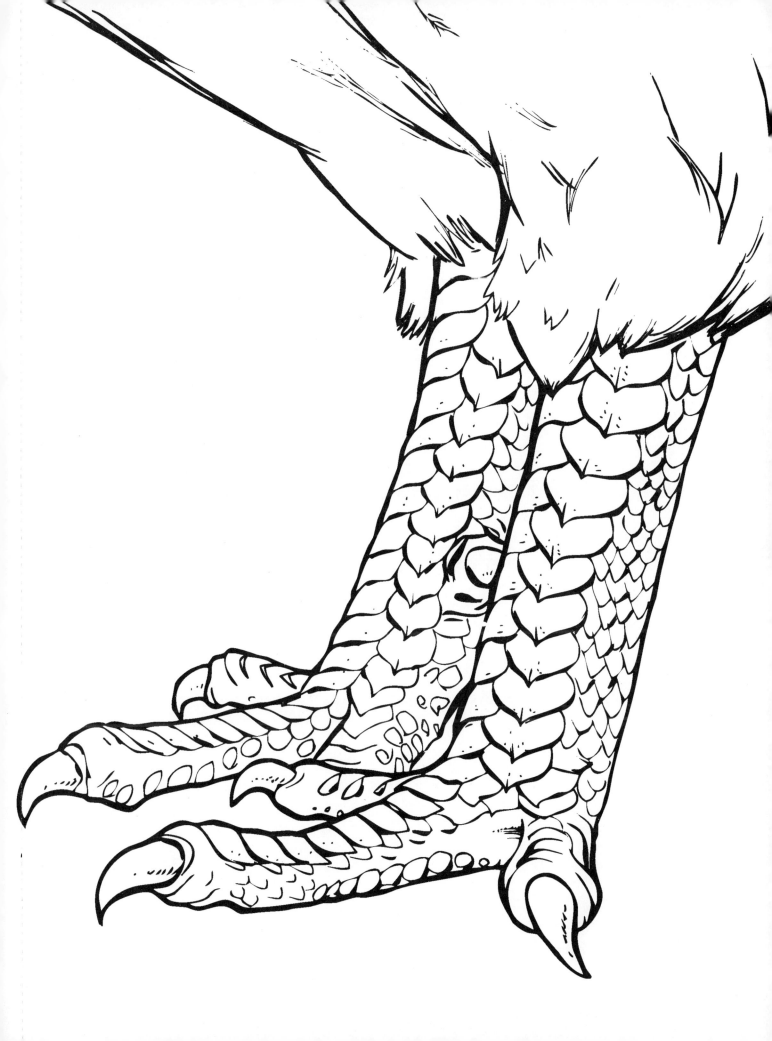

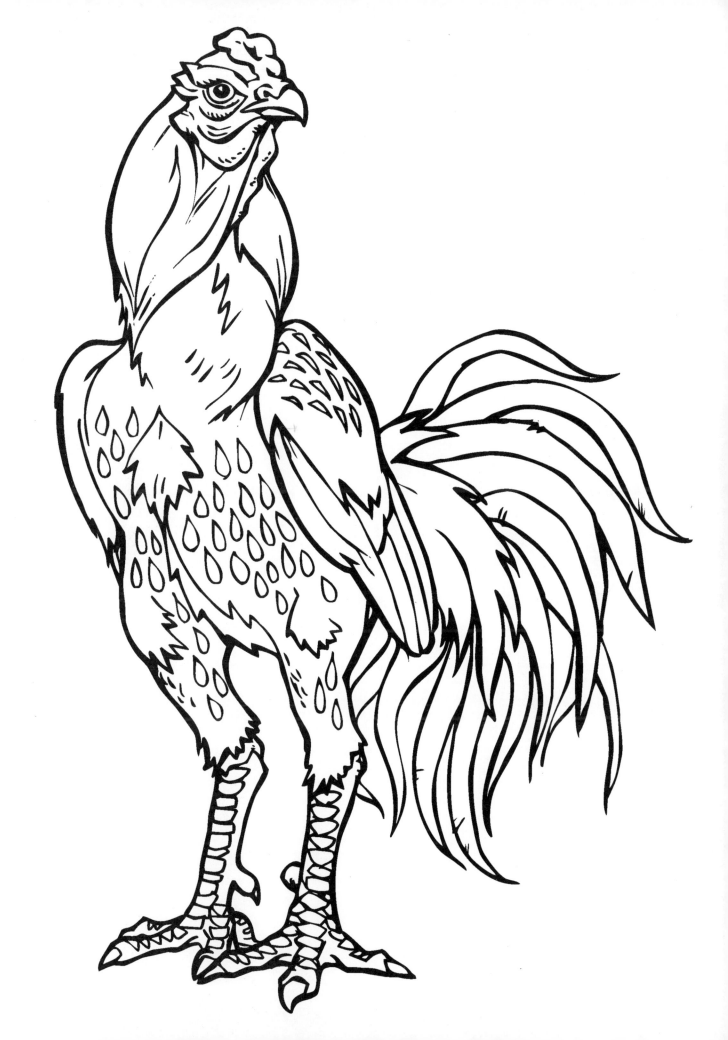

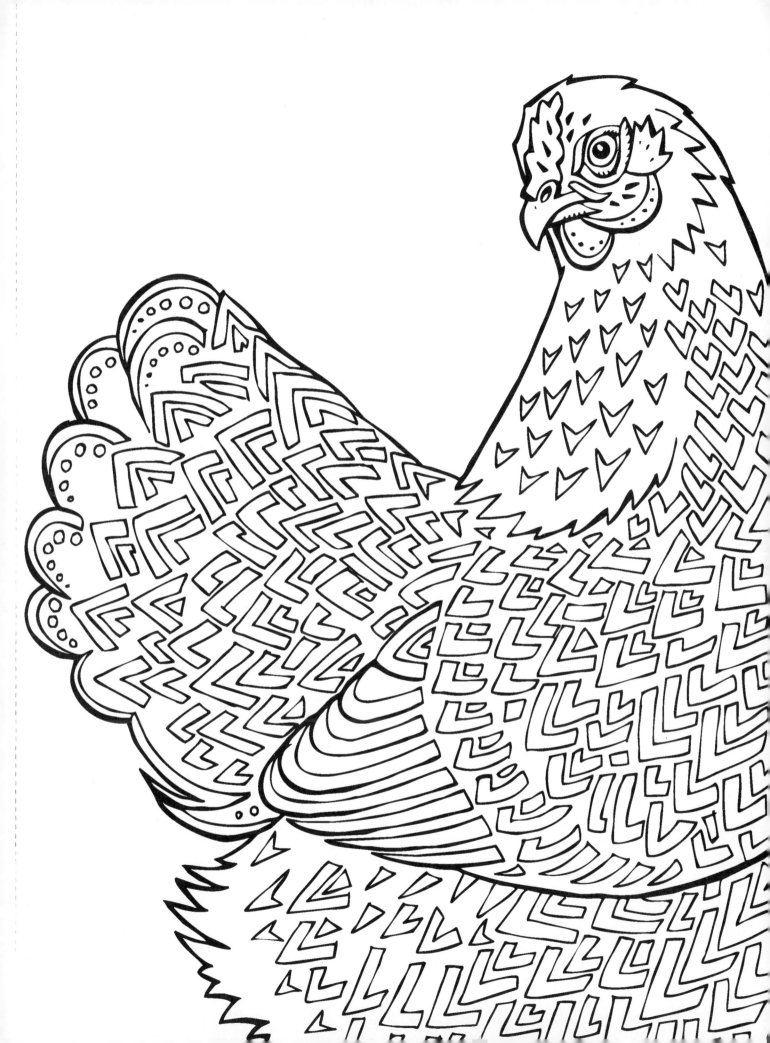

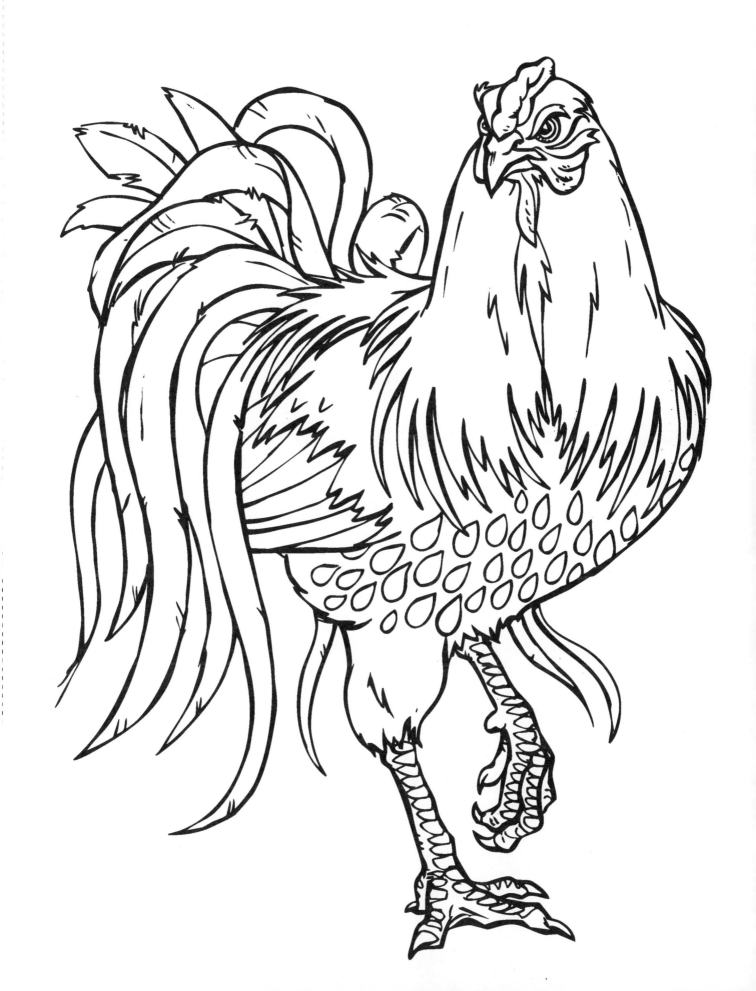

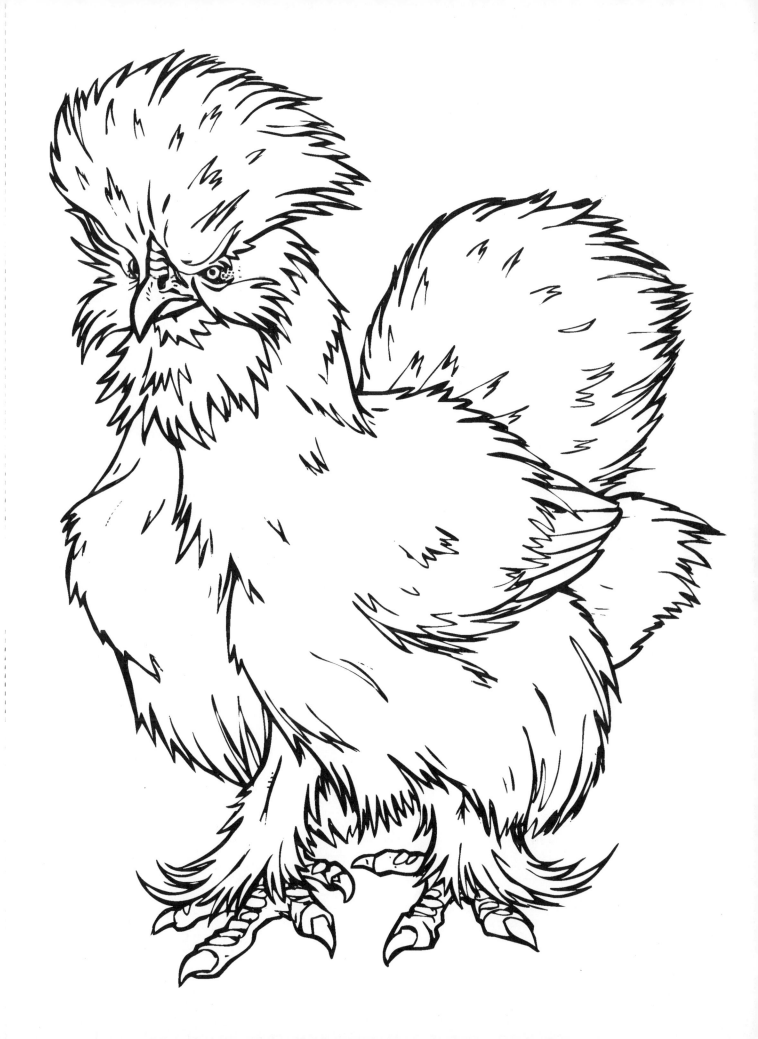

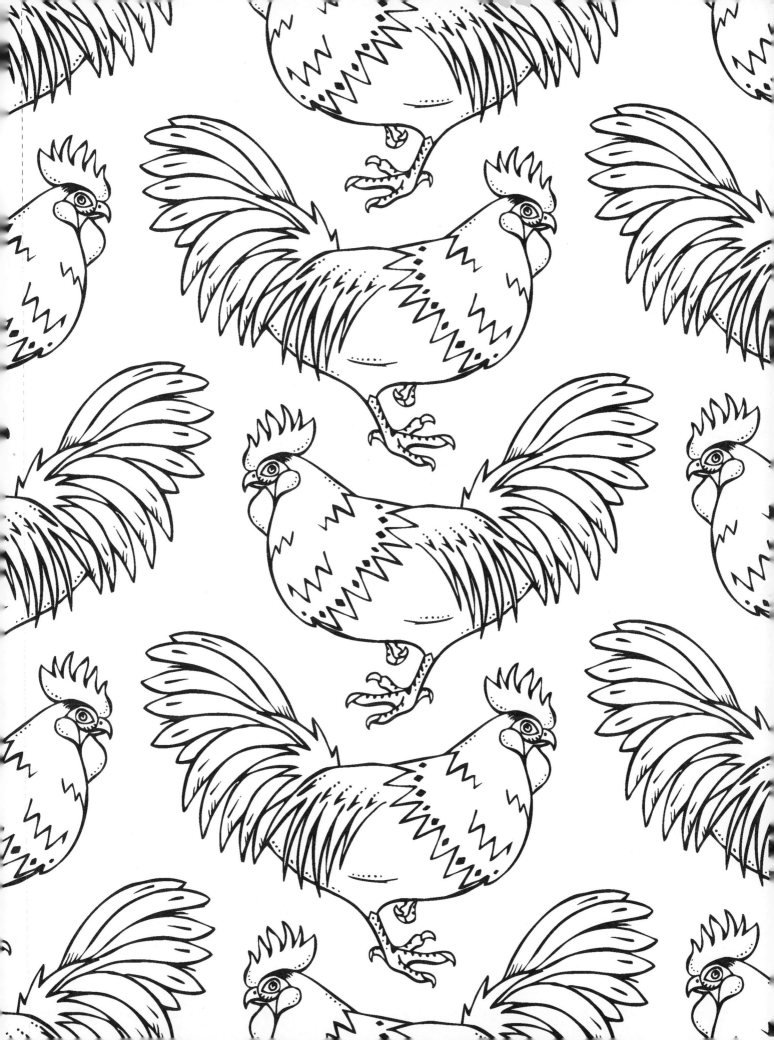

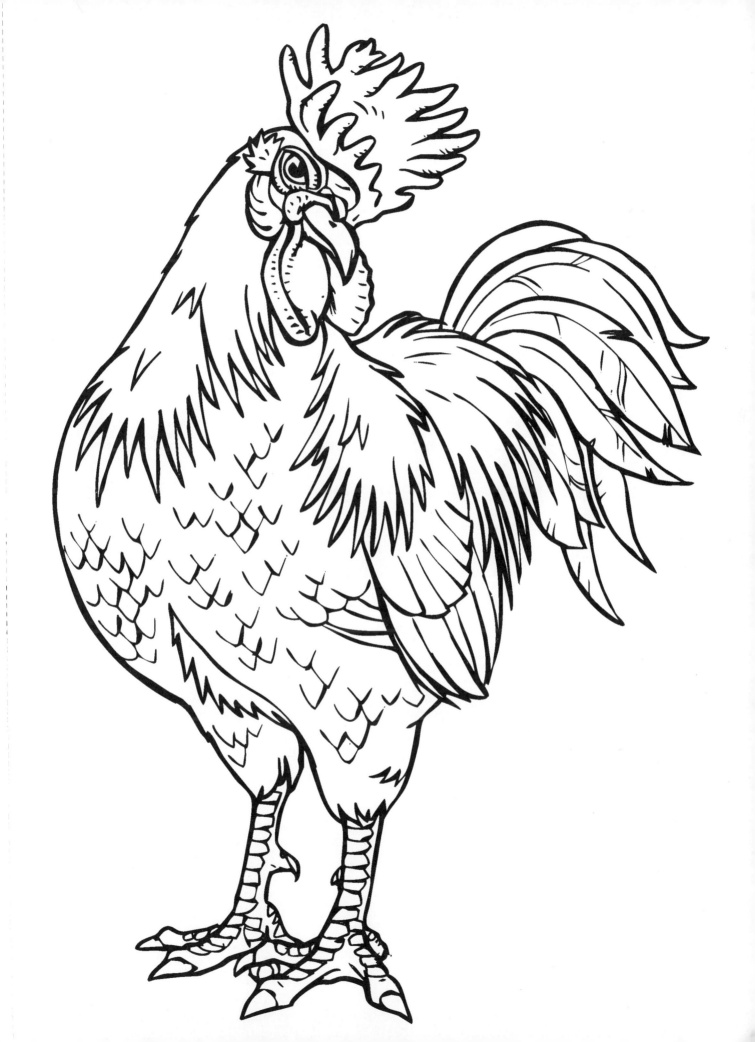

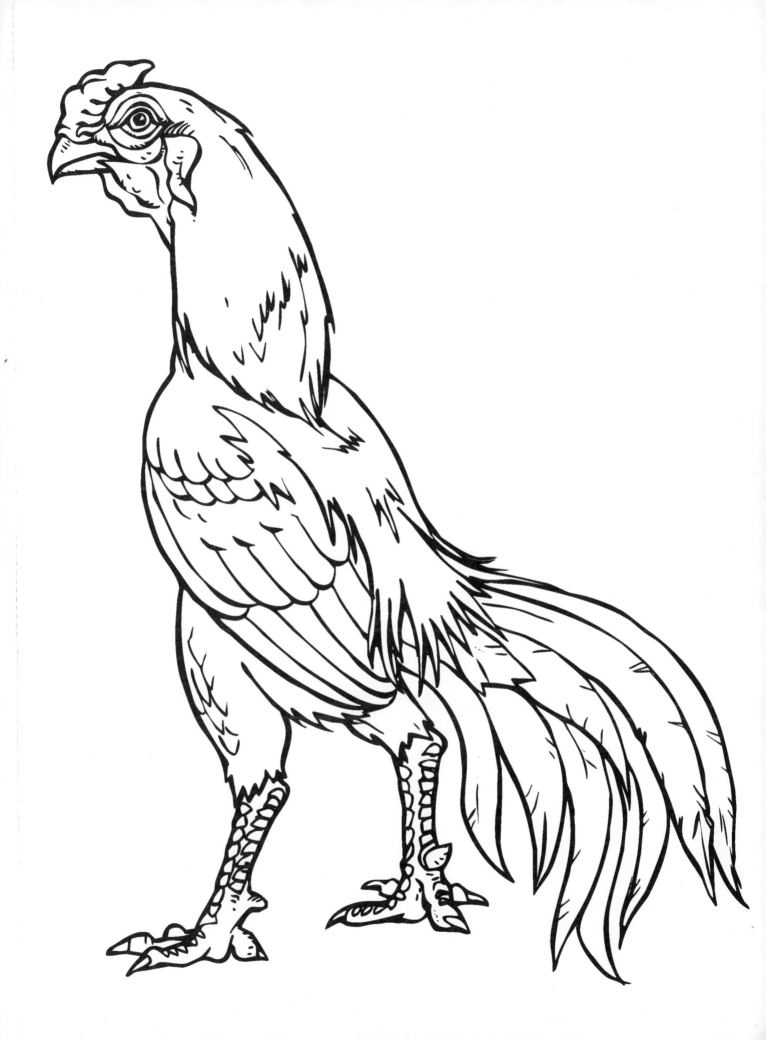

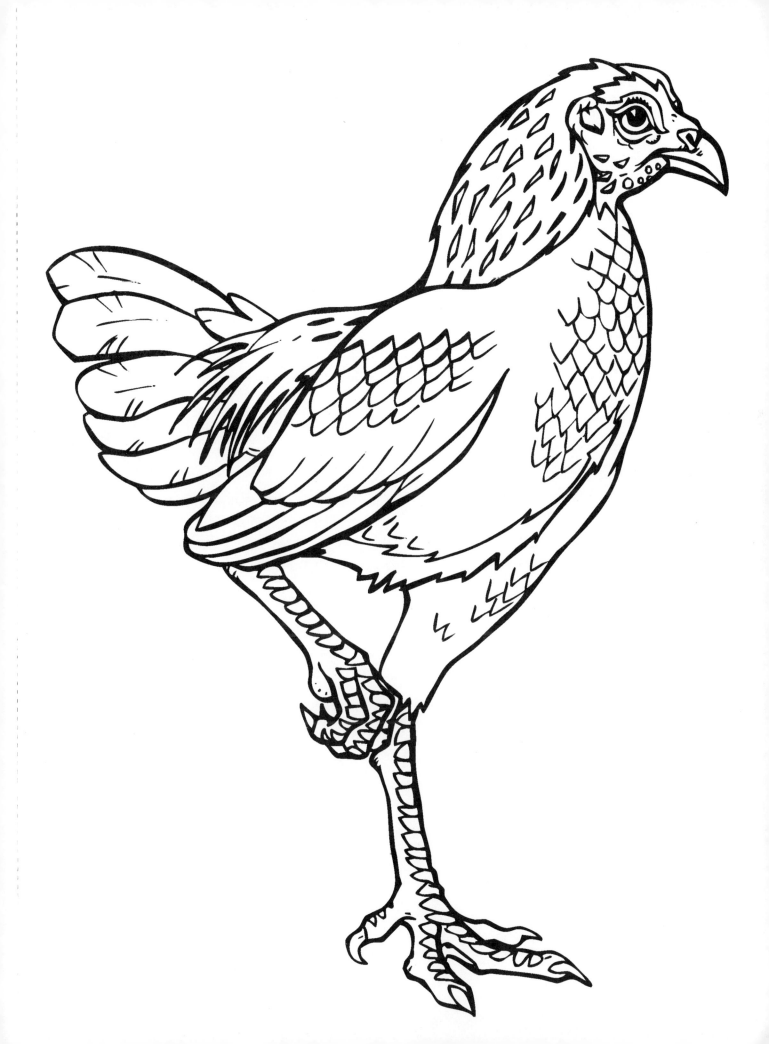

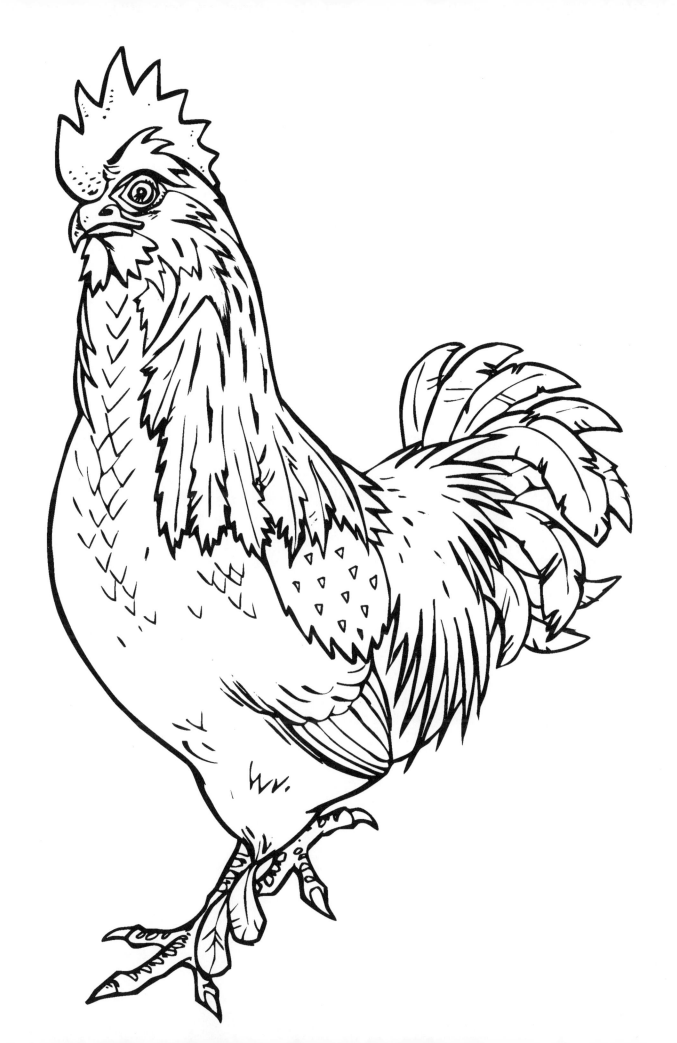

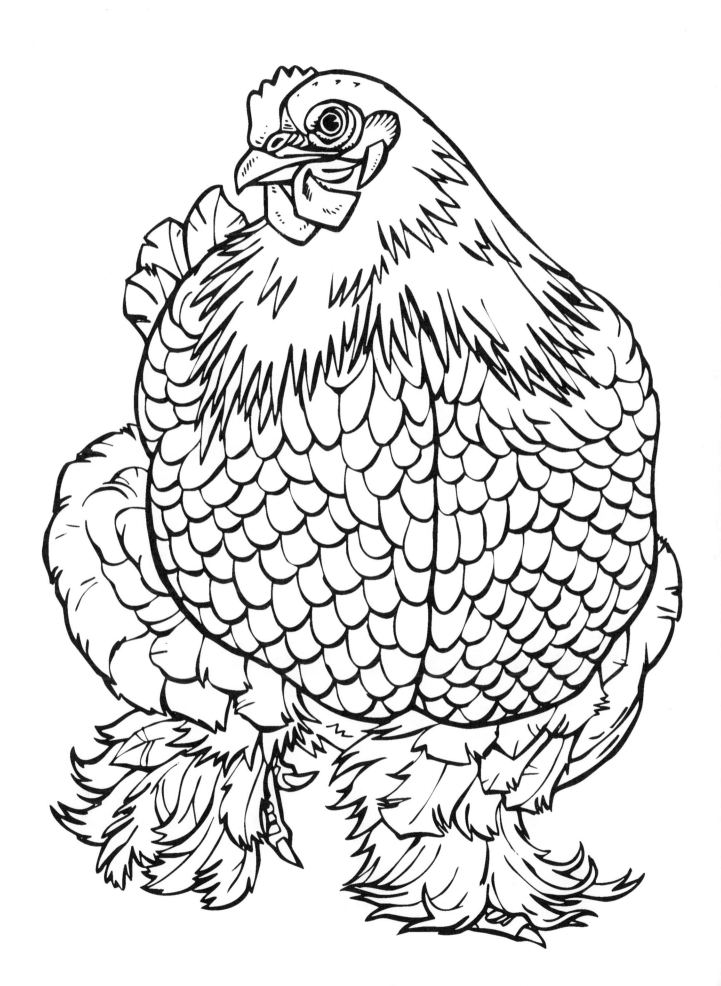

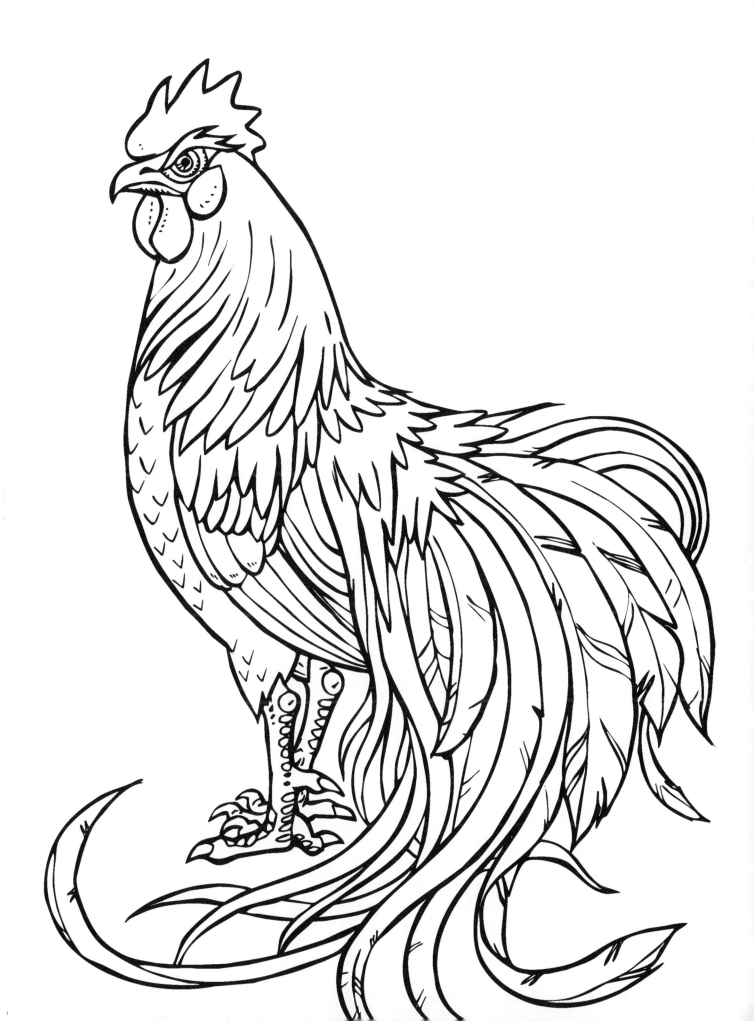

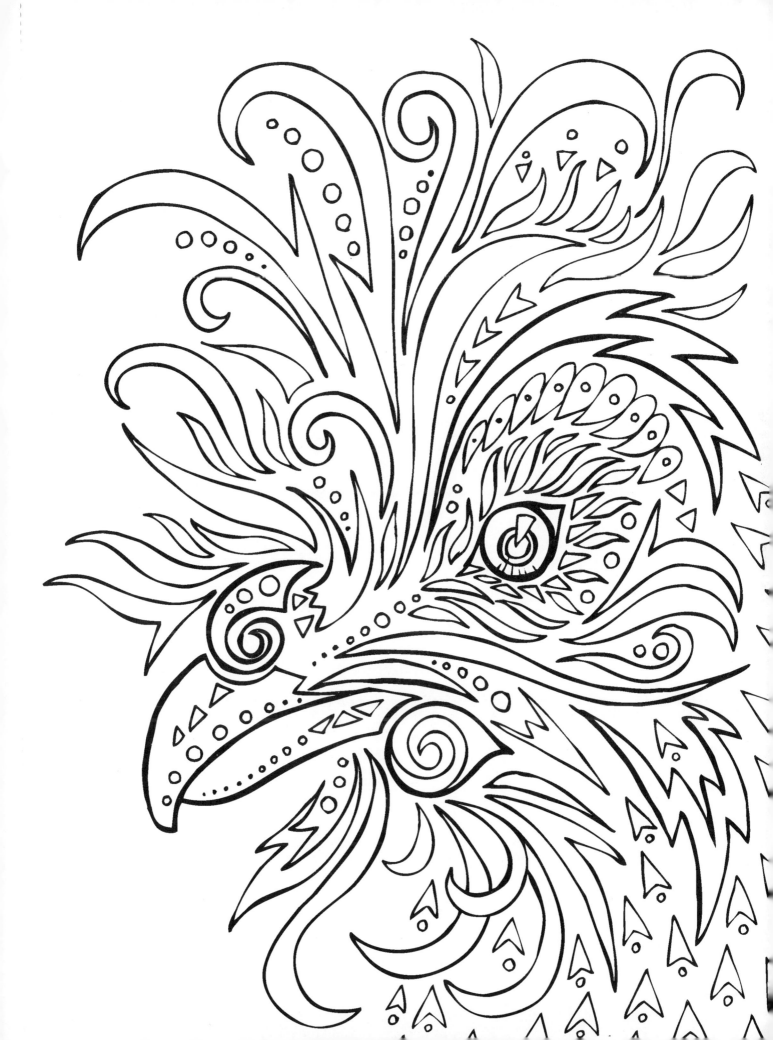

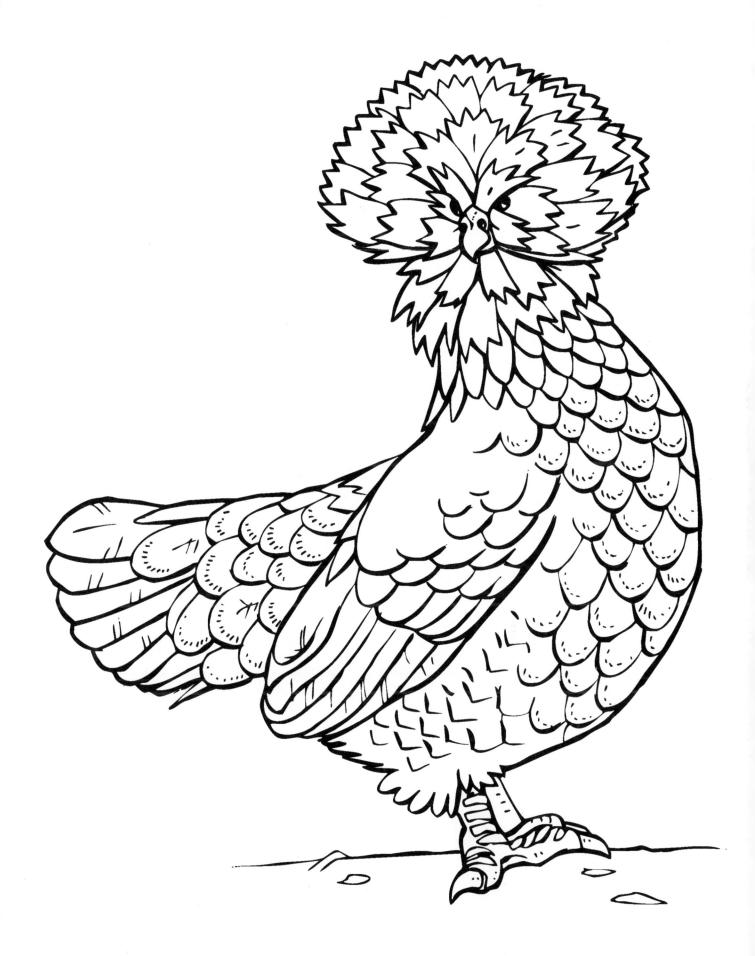

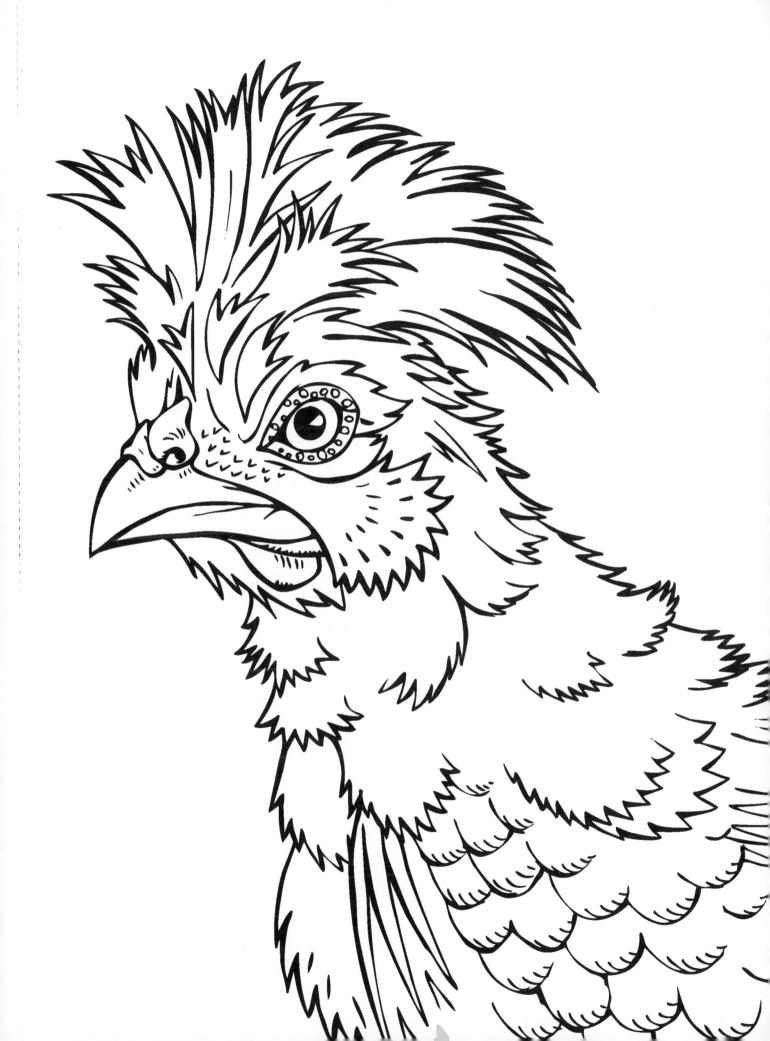

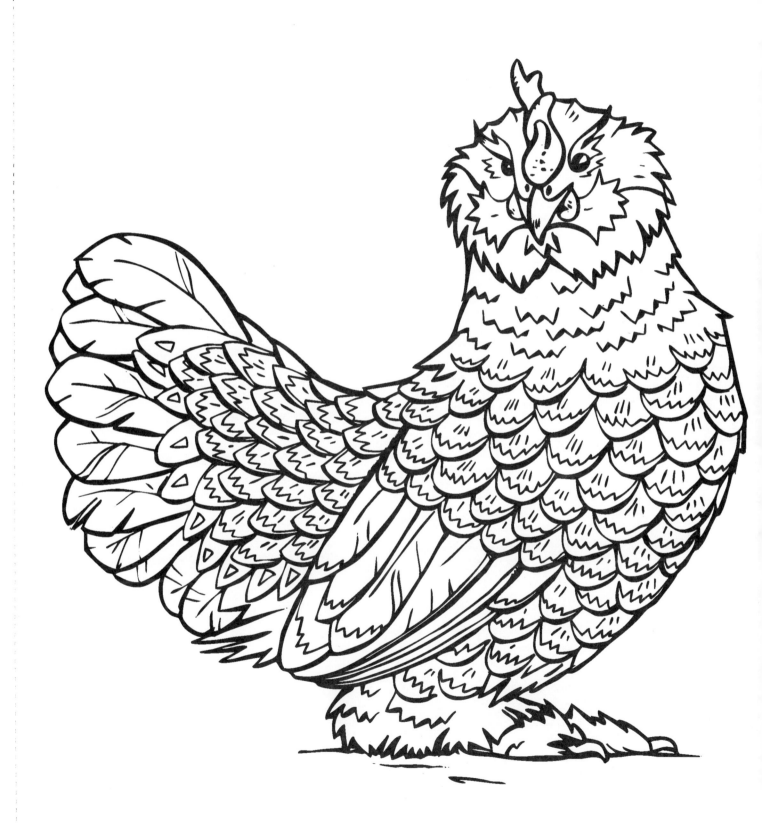

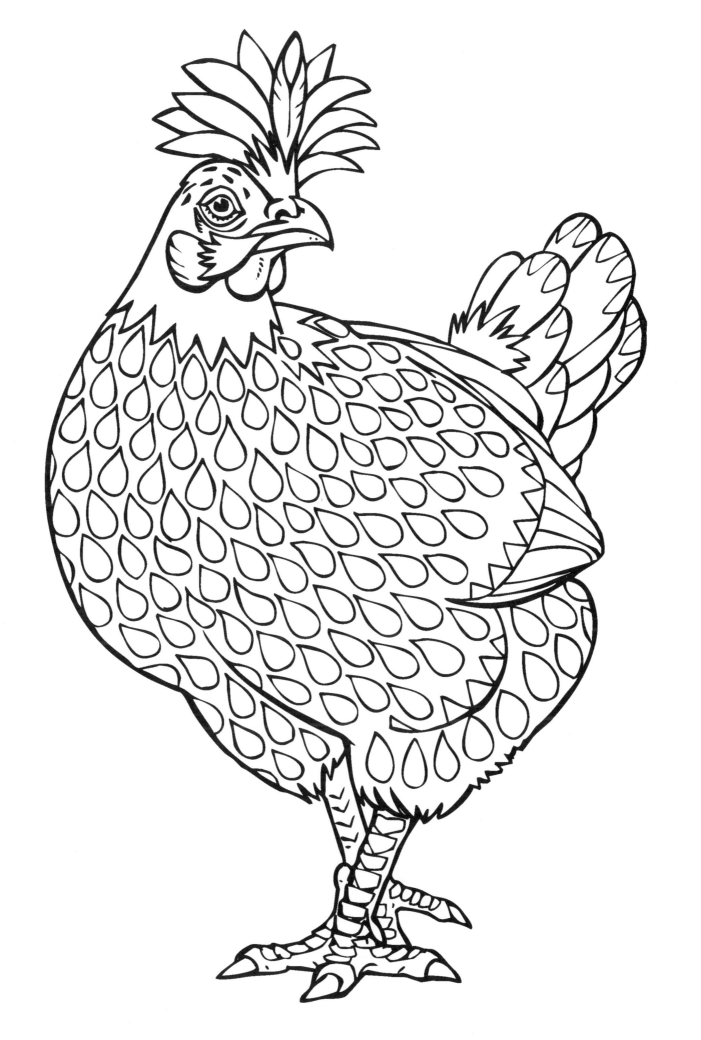

Color Bars

Color Bars

Also Available from Skyhorse Publishing

Creative Stress Relieving Adult Coloring Book Series
Art Nouveau: Coloring for Artists
Art Nouveau: Coloring for Everyone
Butterfly Gardens: Coloring for Everyone
Curious Cats and Kittens: Coloring for Artists
Curious Cats and Kittens: Coloring for Everyone
Mandalas: Coloring for Artists
Mandalas: Coloring for Everyone
Mehndi: Coloring for Artists
Mehndi: Coloring for Everyone
Nature's Wonders: Coloring for Everyone
Nirvana: Coloring for Artists
Nirvana: Coloring for Everyone
Paisleys: Coloring for Artists
Paisleys: Coloring for Everyone
Tapestries, Fabrics, and Quilts: Coloring for Artists
Tapestries, Fabrics, and Quilts: Coloring for Everyone
Whimsical Designs: Coloring for Artists
Whimsical Designs: Coloring for Everyone
Whimsical Woodland Creatures: Coloring for Artists
Zen Patterns and Designs: Coloring for Artists
Zen Patterns and Designs: Coloring for Everyone

The Dynamic Adult Coloring Books
Marty Noble's Sugar Skulls: Coloring for Everyone
Marty Noble's Peaceful World: Coloring for Everyone

The Peaceful Adult Coloring Book Series
Adult Coloring Book: Be Inspired
Adult Coloring Book: De-Stress
Adult Coloring Book: Keep Calm
Adult Coloring Book: Relax

Portable Coloring for Creative Adults
Calming Patterns: Portable Coloring for Creative Adults
Flying Wonders: Portable Coloring for Creative Adults
Natural Wonders: Portable Coloring for Creative Adults
Sea Life: Portable Coloring for Creative Adults